ISLANDERS

ISLANDERS

DOUGLAS SIMONSON

Boston • Alyson Publications, Inc.

The Artist:

Douglas Simonson was born and raised in the ranch country of western Nebraska. Encouraged by his mother, he began painting at the age of fifteen. Today, he specializes in portraying young men of the Pacific, with their varied ancestries. Unlike most artists, however, he uses a remarkable range of styles and techniques in depicting his subject matter.

Simonson has now been painting for nearly twenty-five years. He has had several one-man shows in Honolulu, and has been included in the prestigious "Artists of Hawaii" exhibition shown annually at the Honolulu Academy of Arts. His work previously appeared in the book *Hawaii,* and is available in limited-edition lithographs, as 35-mm slide portfolios, and on notecards. For information about purchasing his work or reproductions, write the artist's studio at 4614 Kilauea Avenue, Suite 330, Honolulu, Hawaii, 96816.

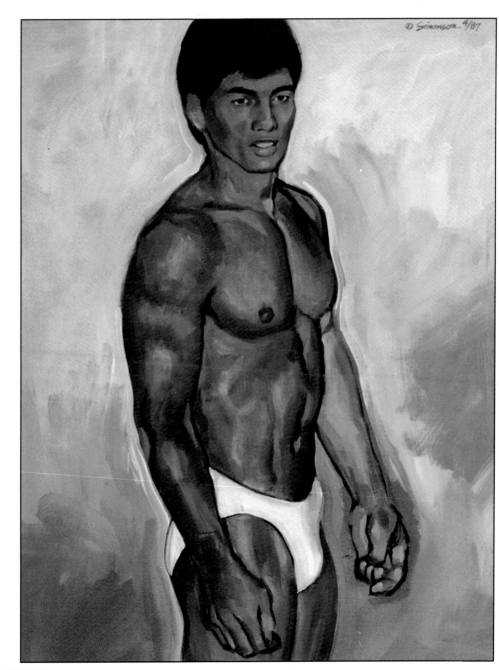

Clean-Cut (Boy from Waialua): Acrylic, April 1987. I poured all my energy into this painting, finishing it in a single night. With his white trunks, short hair, and perfect body, this athlete represents for me the Hawaiian version of the "All-American Boy."

5

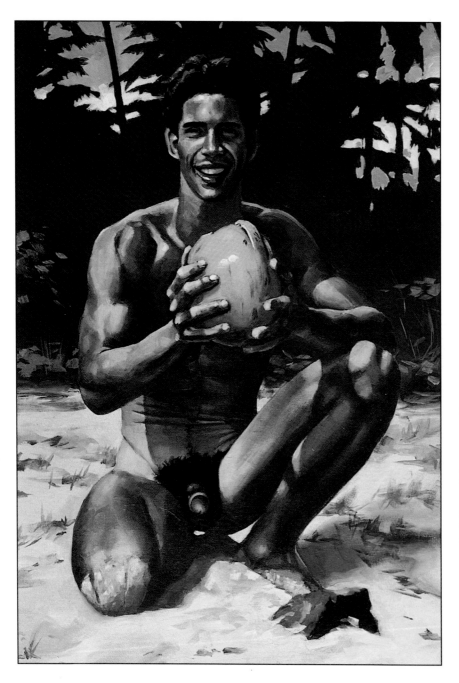

6

Coconut Milk: Acrylic, September 1987. I took Dwayne to a spot on the North Shore of Oahu for a photo session. Naked, he climbed nimbly up a palm tree, got a coconut, climbed back down and cracked it open, tipped it up and drank the juice. Moments later, I took the photograph which produced this painting.

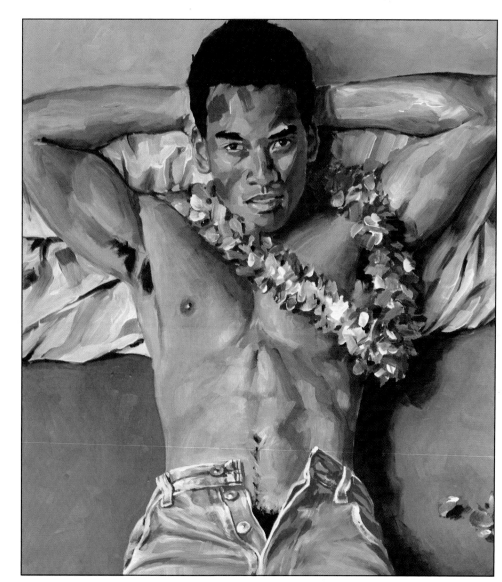

Siam Orchids: Acrylic, April 1988. Wearing only jeans and an orchid lei, Michael, born in Thailand, posed for me on the lanai of my Kapahulu apartment. I used a dynamic, slashing brushstroke to suggest the angularity of Michael's features and the strength of his pose. This is Michael's favorite painting of himself.

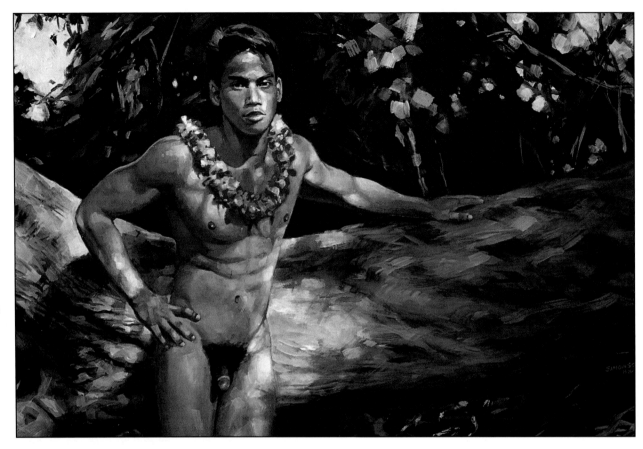

8

Mountain Trail: Acrylic, August 1988. For another view of this setting and model, see "Waahila." Here again I've used the marvelous flexibility of acrylic paints to portray the dappled light on Michael's body and the rough bark of the tree. The warm sunlight is contrasted with the cooler blue of the sky, silhouetting the tropical foliage found along the ridges of the Koolau mountains.

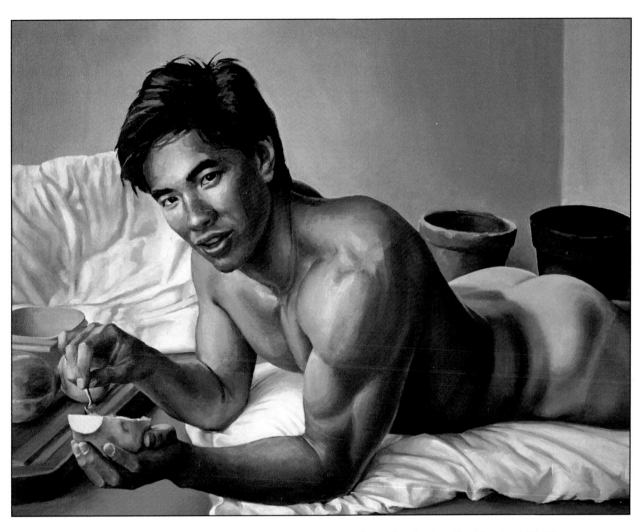

Spooning It: Acrylic, March 1987. I love papayas. So one day during a modeling session on my lanai, I went to the kitchen and got one for my model. He sliced it open, spooned the seeds into a plastic bowl, and began to eat, casting a mischievous glance toward me. I spent over a month working on this richly detailed 30''x40'' painting.

10

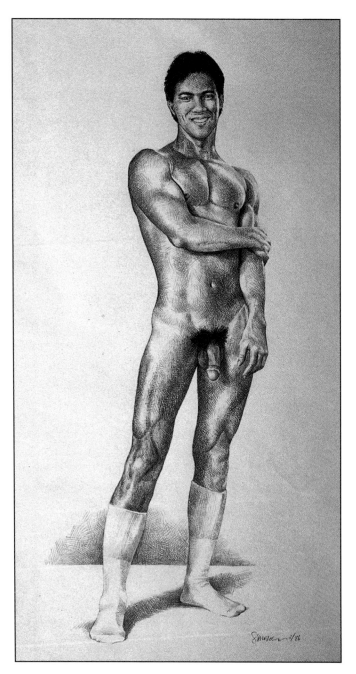

Sweat Socks: Pencil, February 1986. This drawing is based on a young Hawaiian actor I know. I drew it using my memory of his face and a photograph of another model's body. I put them together to create one of my favorite fantasies: catching someone who looks like this with just his socks on.

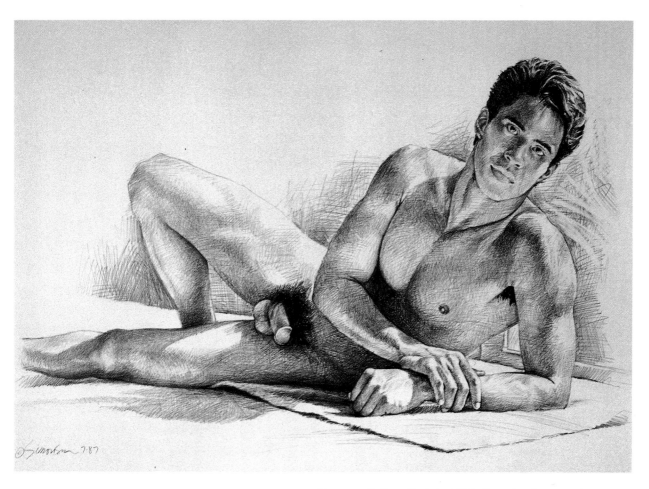

Dwayne II: Pencil, July 1987. One day I got a phone call from a young woman suggesting that her boyfriend would be a perfect model for me. She was right. This is one of the first of many drawings and paintings I've done of Dwayne, who is 21 and Hawaiian-Filipino.

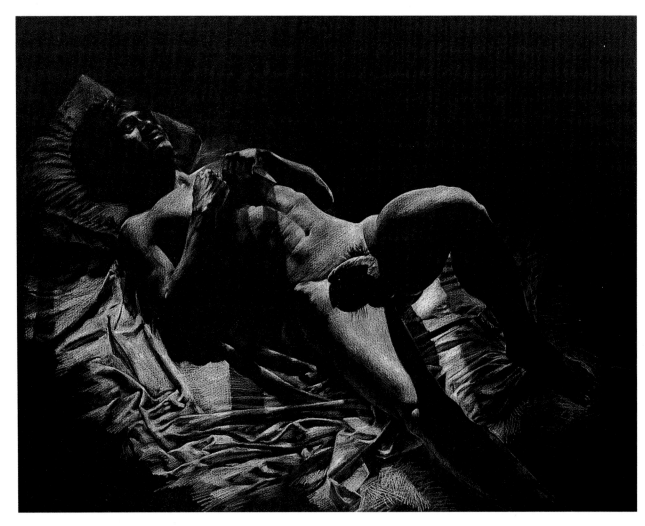

12

Moonrise: White Pencil on Maroon Paper, 1985. This
medium, white pencil on dark paper, is unbeatable for
achieving a certain mood. This picture, even though
I'm the one who drew it, still contains mystery for me.
When I look at it I become caught up in the fantasy of
observing this young man lying on his bed alone in
the moonlight, dreaming of someone he loves.

Bittersweet: Pencil, November 1987. While photographing this young Hispanic-Filipino man in my Kapahulu apartment, I caught him staring out from my lanai toward the Koolau mountains, lost in memories. I emphasized his mood with strong, angular pencil strokes.

13

14

Bird of Paradise: Acrylic, June 1986. This painting was
the first in an erotic, decorative style I refer to as "Eros
Deco." Painting it was an extraordinary experience: I
painted nonstop for a week, as if possessed. I was a tool
for this painting. It painted itself. Though the face is one
of the simplest I have ever painted, it is one of the most
powerful, creating an unmistakable presence. I still have
this painting in my private collection.

Hula Dancer: Acrylic, November 1987. Kahiko, or Ancient Hula, is an art form studied by many young men in contemporary Hawaii. Here I've portrayed a Hawaiian-Chinese-Filipino-Spanish dancer wearing a traditional head lei.

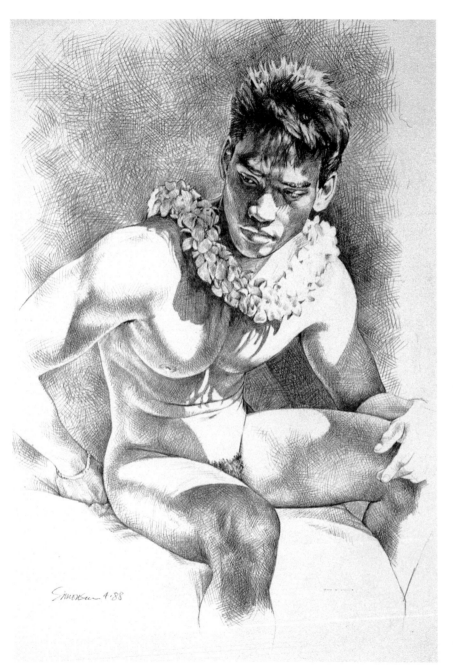

Waikiki Window: Pencil, April 1988. I pose Michael in the early-afternoon light streaming in through the Waikiki window of my apartment. He sits on the corner of my bed, the tropical sunlight sculpting his graceful, muscular body and sensual features. I used pencil cross-hatching to express the intricate patterns of light, shadow, and light-within-shadow.

Black on Black: White Pencil
on Black Paper, September
1988. The images I got when I
posed Bruce on my lanai one
morning were so striking I
knew I couldn't capture them
with a typical pencil drawing.
Black skin is highly reflective,
and posing Bruce against a
white wall yielded striking
contrasts. White pencil on
black paper proved to be the
ideal medium for creating
this powerful visual
statement.

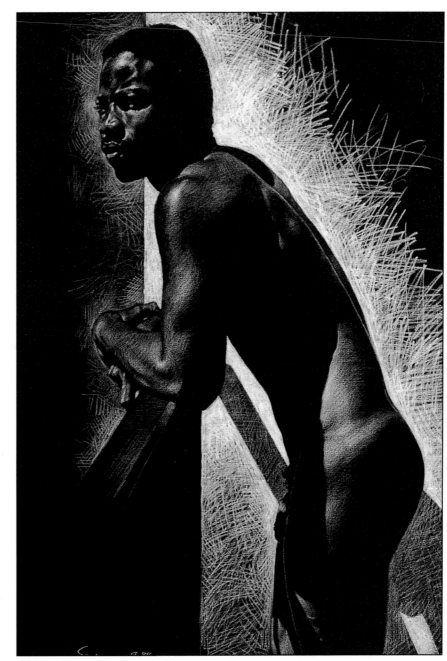

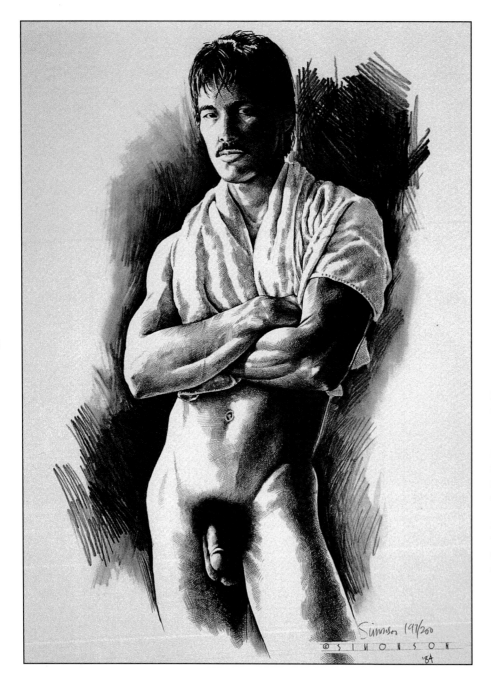

Dane: Limited-Edition Print from Pencil Drawing, 1984. Dane is a character in a private fantasy. I based him on a friend of mine, a part-Hawaiian, part-Japanese, part-Filipino guy, but the result is my own invention — a handsome Island boy in that totally unself-conscious "locker-room" stance.

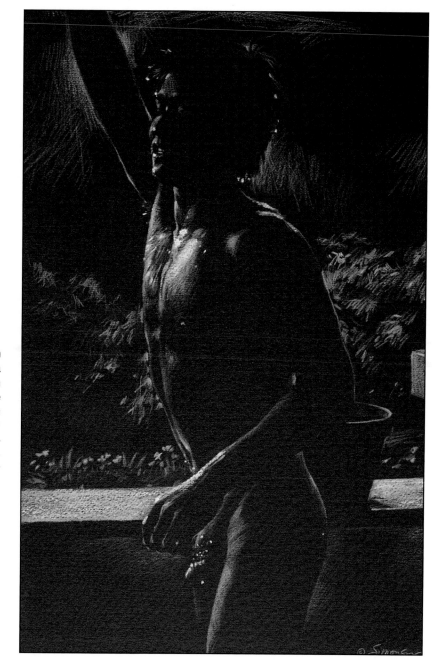

Rainy Afternoon: White Pencil on Blue Paper, September 1987. In a house deep inside a Hawaiian valley, I had my young Chinese friend jump in the bathroom shower and get wet, so that I could photograph him in the late afternoon light. As he returned to the front porch, a tropical shower began, and the sun shone through the rain to illuminate his glistening body.

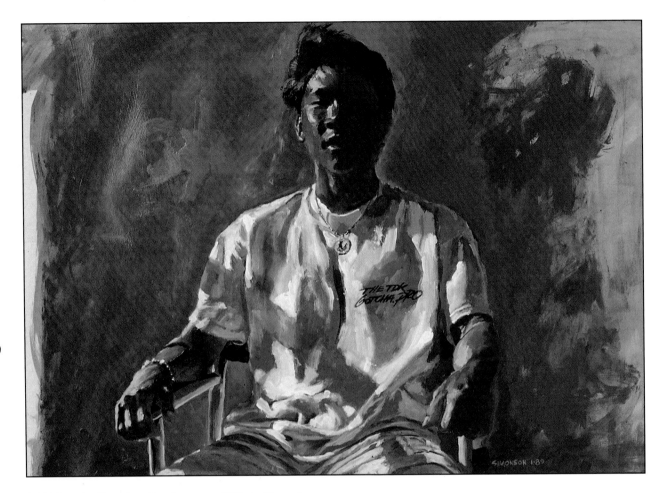

TDK-Gotcha Pro: Acrylic, January 1989. In Hawaii, you
see this boy everywhere. He's the archetypal "local
kid" who lives for the sun and the beach and the
ocean, and who never stays still for more than a
moment. To convey this energy, I dispensed with the
brush. Instead, I used wadded-up tissue paper:
rubbing, blotting, dabbing, scrubbing, to capture
on paper the energy and excitement I felt.

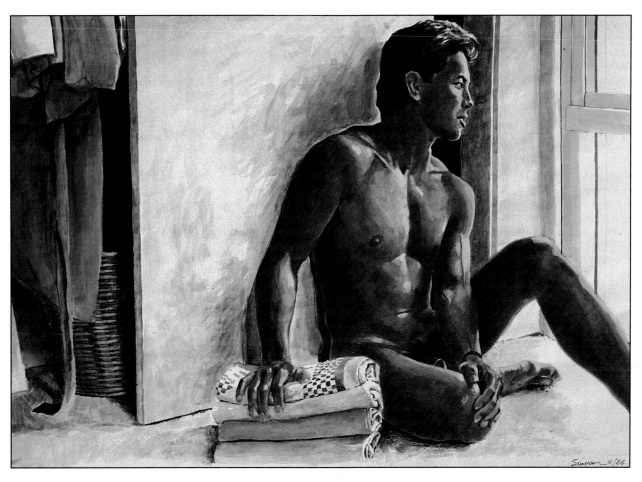

Cinnamon: Acrylic as watercolor, April 1986. One day while photographing Randy, I ran out of ideas for poses, and asked him to fold my laundry for me. Here he's just finished, and rests a graceful hand on the pile of clean towels. I used about 10 layers of color — red, blue, and yellow — to create these luminous "cinnamon" skin tones.

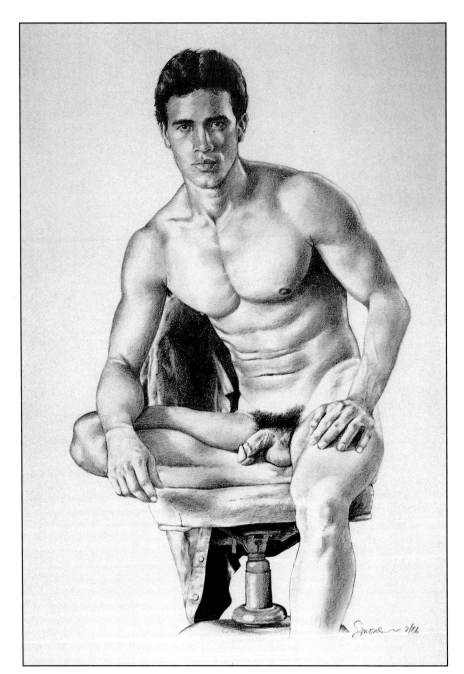

Young Portuguese: Pencil, February 1986. For me, if it's not happening in the eyes, it's not happening. I've done drawings which were perfect in every respect except that the eyes weren't *alive* — and torn them up. This model has a beautiful, strong body, but you don't really feel his strength — and everything else — until you look into those eyes. The chair is the one I sit on when I draw.

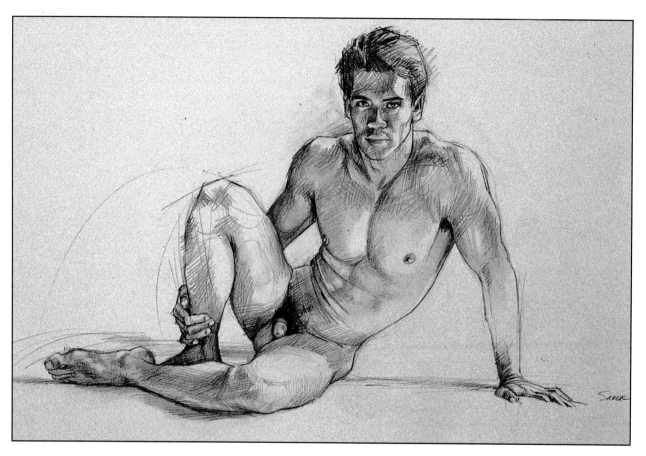

Dwayne IV: Limited-Edition Print from Pencil Drawing, June 1988. Some of my models are shy and self-conscious — but not Dwayne! He has a wonderfully appealing confidence that causes him to naturally assume casual, sensuous poses like this one. I used strong, sweeping strokes of the pencil to emphasize Dwayne's uncomplicated masculinity.

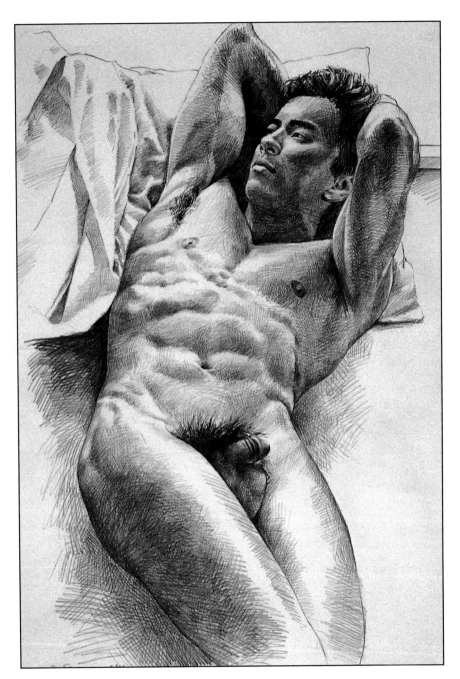

24

A Thousand Words: Pencil, August 1986. This is a beautiful young Filipino-Hispanic friend of mine. When I drew this image of him, my objective was to *feel* the light moving across his muscles, so that the viewer would feel the body itself.

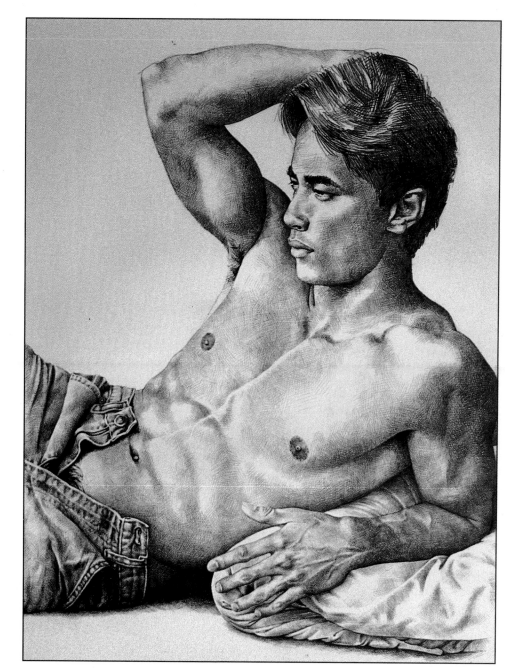

Todd: Pencil, February 1987. Todd is a symbol for me of the beauty of a certain kind of man. He's graceful yet masculine, sensitive yet strong. Those qualities show not only in his face but in his hands. I used cross-hatching (parallel lines overlaid to create shadows) to suggest the textures of the cloth in the jeans and the pillow, and to make real the subtle and powerful forms of Todd's body.

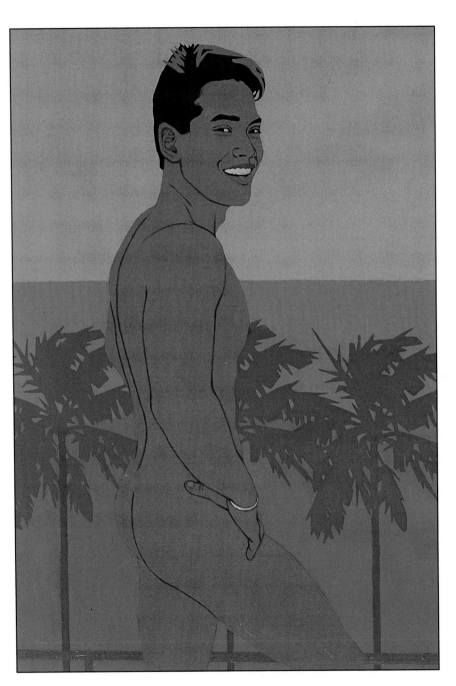

Chocolate Shake: Acrylic, May 1988. This painting represents all the things I love about Hawaii: the ocean, the palm trees, the riotous colors that seem to vibrate under the tropical sun — and especially the delicious, inviting vision of suntanned youth in the center.

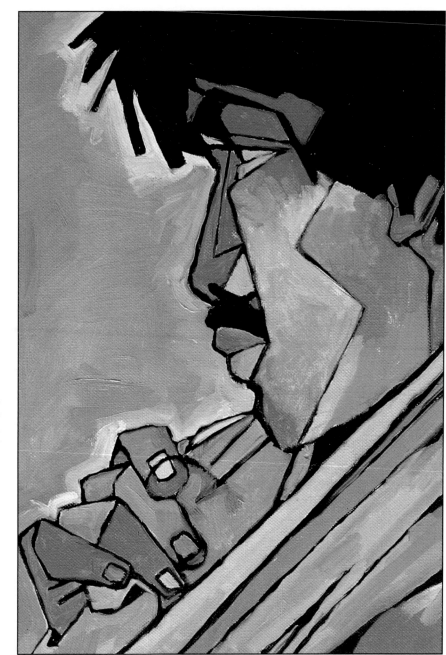

The Face: Oil, 1985. In this experimental work, a pre-cursor of the Eros Deco style, I gave the planes of my model's face an angular, almost cubist interpretation.

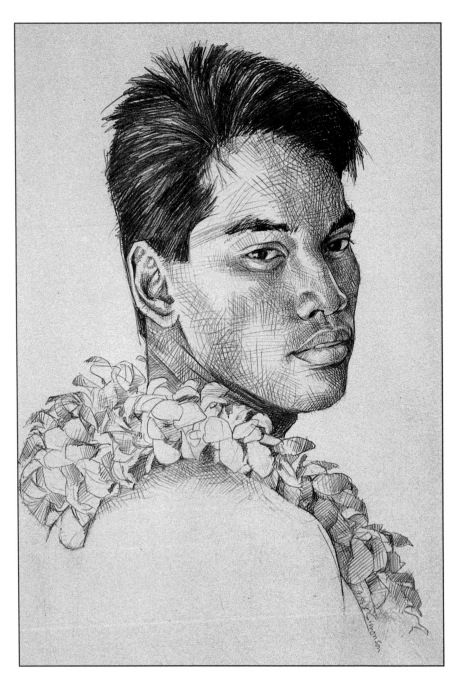

Thai Boy: Pencil, April 1988.
Though he grew up in Hawaii,
Michael is pure Thai, and his
face reflects that special kind
of beauty. I portrayed the
graceful planes and angles of
his features with a loose,
open style of cross-hatching.

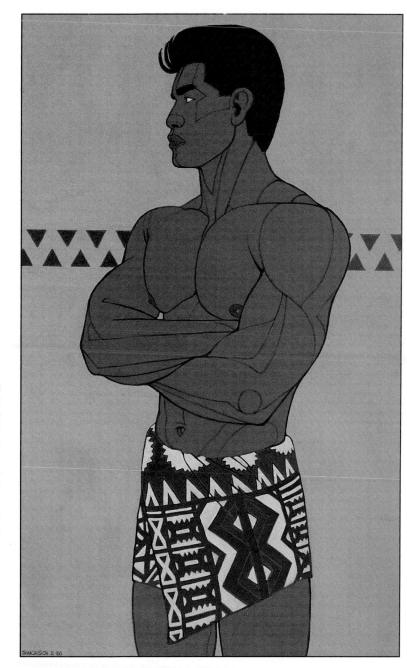

Kane: Acrylic, January 1988. I met a very muscular young Hawaiian man while working out in the gym of the Central YMCA in Honolulu. I asked him to model, and he showed up wearing a pareu printed in traditional Hawaiian tapa designs. I used the Eros Deco style to create an icon of masculine Polynesian pride and strength. (Kane is pronounced KAH-nay, and is Hawaiian for "man.")

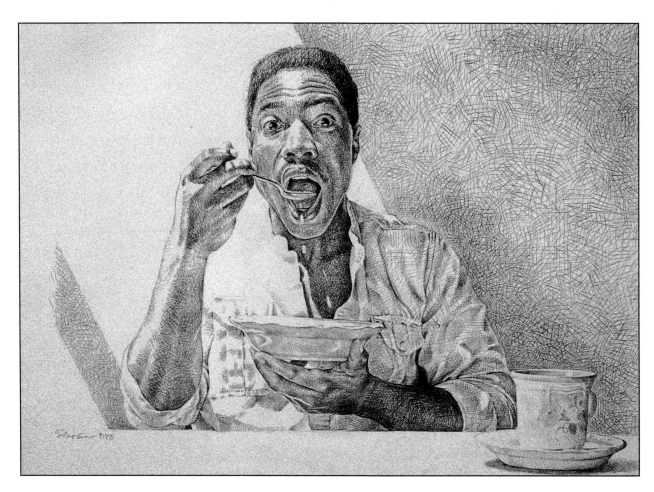

Breakfast with Bruce: Pencil, September 1988. Bruce
is a young black man who lives in Honolulu and happens
to be one of my best friends. I snapped a series of
photographs of him one morning eating breakfast on my
lanai. I loved capturing Bruce's energy, animation, and
joie de vivre.

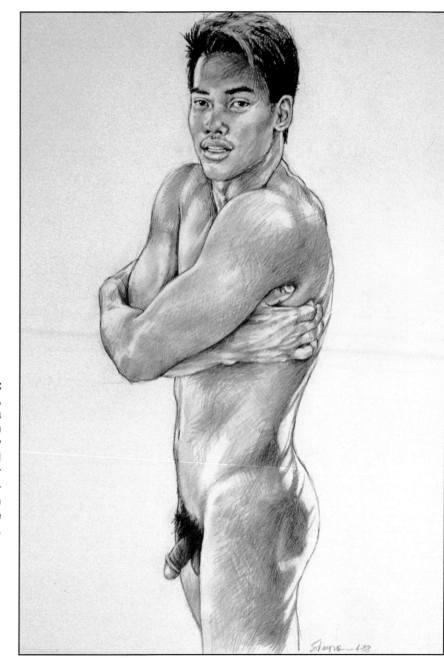

Michael in the Morning:
Pencil, June 1988. Michael,
my Thai model, stood in a
clearing on top of a mountain
above Honolulu one chilly
early morning while I
snapped photographs. I later
chose this image and encap-
sulated a breathless, frozen
moment with a soft graphite
pencil.

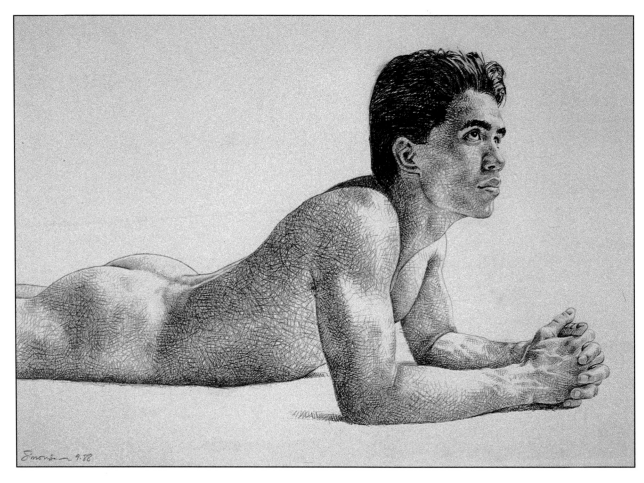

32

Hawaiian Boy: Pencil, September 1988. Dwayne's eyes
are so haunting and expressive that they dominate every
image I create of him. Here he looks upward into the
light, which seems to fill his eyes. I used a cross-
hatching technique which allows more light into the
shadows — so that even the dark places in this drawing
are luminous.

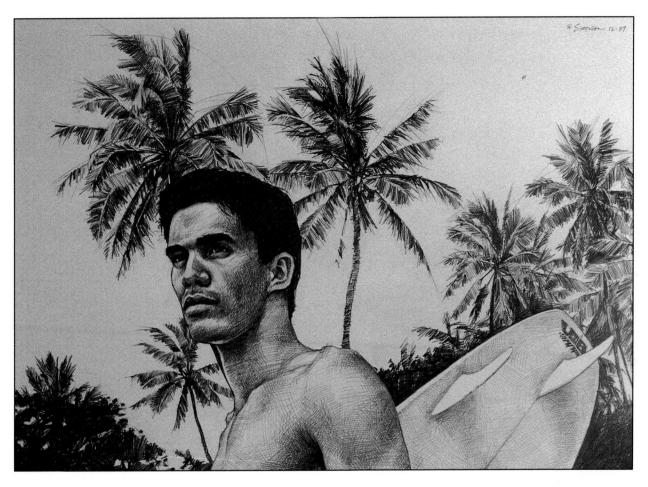

North Shore: Pencil, December 1987. Dwayne poses against the coconut palms he used to climb as a boy on the North Shore of Oahu. Holding his surfboard under one arm, he scans the ocean, waiting for the right moment to enter the crashing waves.

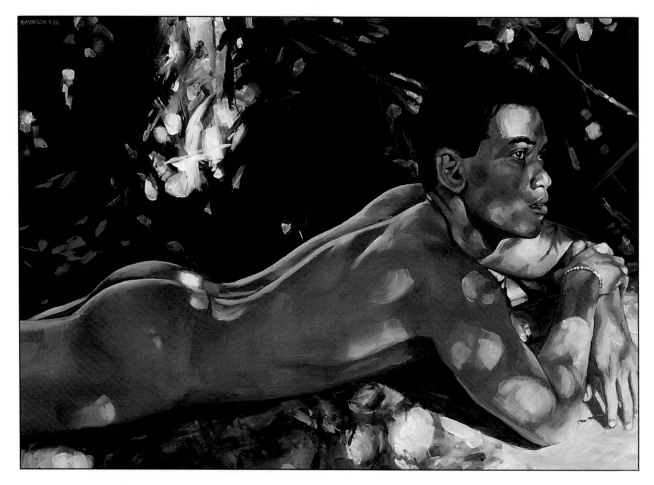

34

Waahila: Acrylic, May 1988. Above Honolulu there is a ridge called "Waahila" (pronounced vah-ah-HEE-lah). I took Michael there one morning and we found a glade where I had him pose on a fallen log. This painting is about the emotional effects of *light* and how it can create a mood, a sense of time and place, even a separate world. This is my most powerful painting to date.

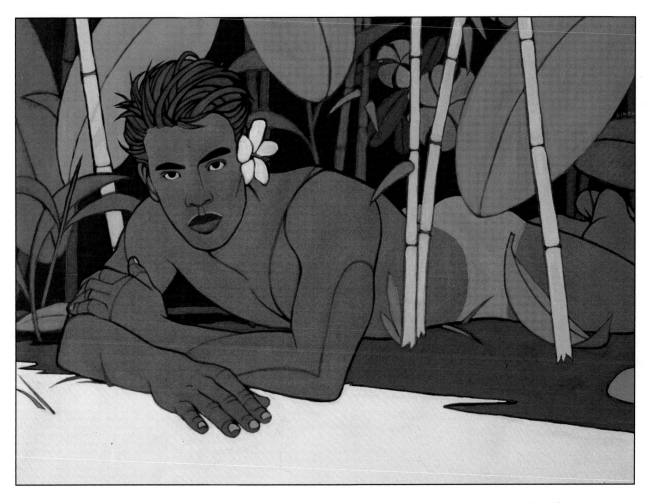

Hawaiian Wildlife: Acrylic, February 1988. One day I was walking through a poster shop in Honolulu, surrounded by colorful images, and had a mental picture of a painting entitled "Hawaiian Wildlife." I "saw" a beautiful Polynesian boy creeping through a tropical rain forest. Over the next few days, using the Eros Deco style and Dwayne as a model, I brought him to life on my easel.

36

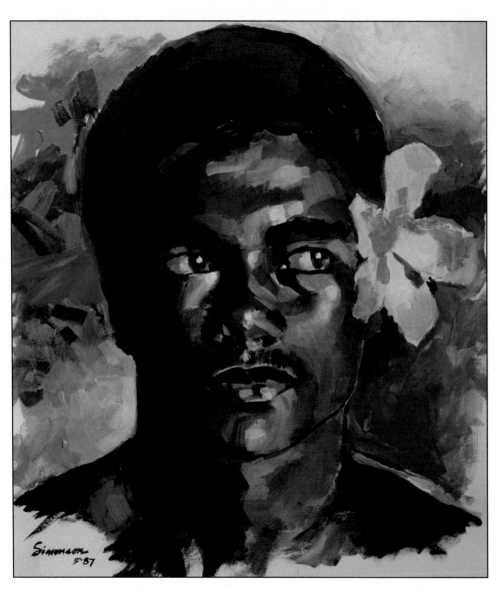

Tusitala: Acrylic, May 1987. One afternoon during a stay at the Tusitala Hotel in Apia, Western Samoa, I was taking photographs of the grounds. A young Samoan man saw me and asked if I would photograph *him*. I did, and later painted this colorful impression-istic portrait.

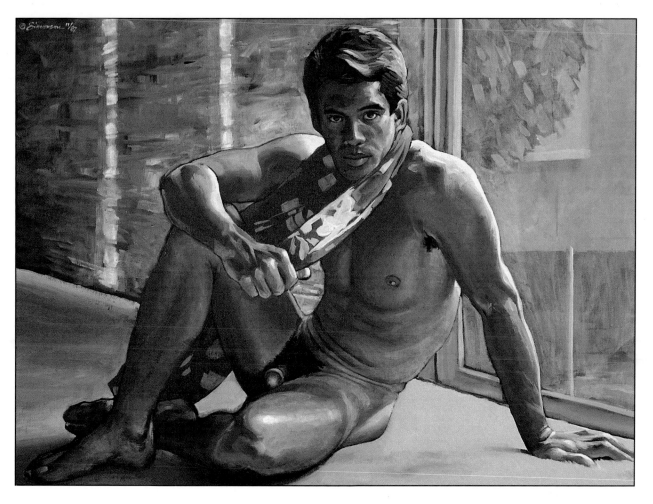

Diamond Head: Acrylic, November 1987. Dwayne lived in a house about 50 feet from the beach, nestled in the shadow of Diamond Head. In this painting I've emphasized his remarkably expressive eyes; the pareu he's wrapped around his neck adds a spot of tropical color.

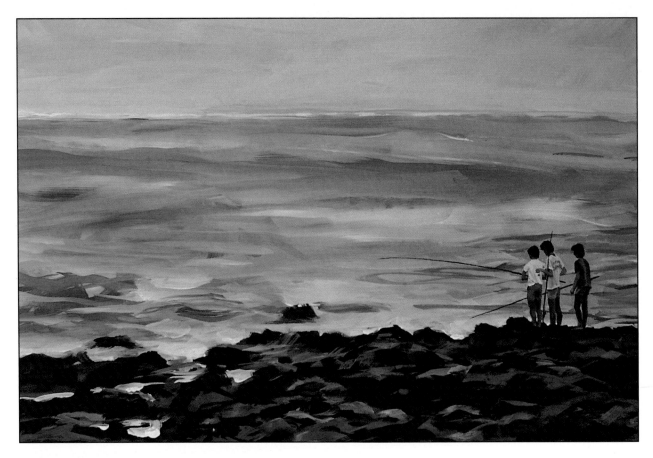

Fishing: Acrylic, July 1988. While driving along the rocky coast between Koko Head and Makapuu Point one cloudy morning, I saw three boys with fishing poles walking toward the ocean. I stopped the car, aimed my camera, and photographed them. I then used acrylic paint and impressionistic brushwork to describe the stormy sea and black lava rocks. The boys were painted last, using a fine sable brush.

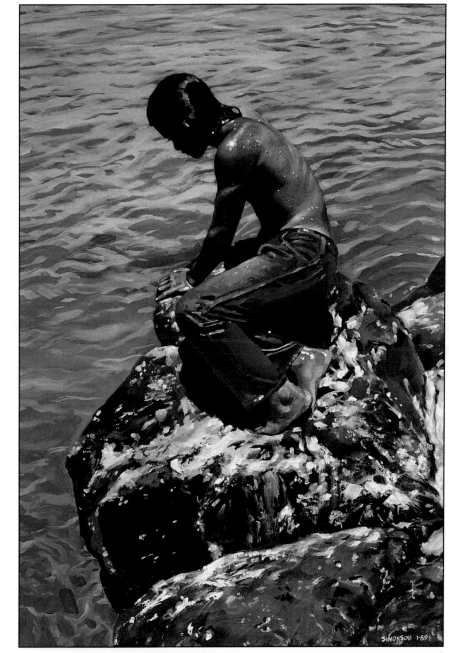

Dolphins: Acrylic, January 1989. I named this painting intuitively. I had seen no dolphins that day at Waimea Bay, and as far as I knew, neither had anyone else. Yet the painting *was* "Dolphins." It wasn't until months later that a close friend looked at the painting and told me about an experience he'd had 15 years before: for the first time in his life he saw, and swam with, a school of dolphins — at the very spot I'd painted.

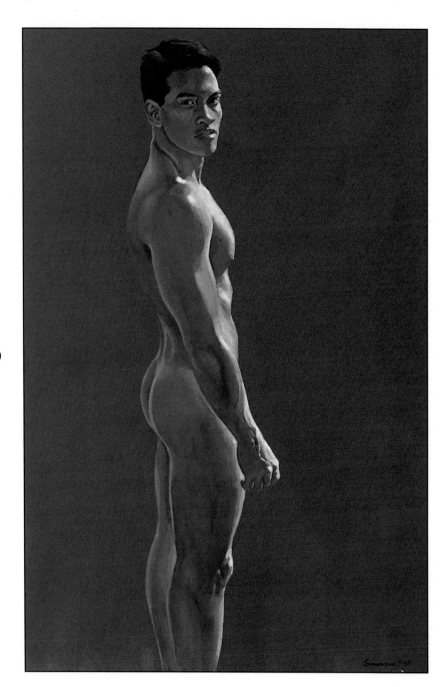

Boy in Red: Acrylic, July 1988. In this painting the early-morning Hawaiian light bathes the front of Michael's body in cool bluish tones, while the background color underlines the warm tones of his sun-bronzed skin. The red of the background is based on the color of the volcanic soil found in the neighborhood where Michael lives.

Orbit: Acrylic, October 1987. Like "Bird of Paradise," this is an Eros Deco painting. From a photograph of a Filipino-Hawaiian boy wrapping a towel around himself in my living room, I created this stylized golden-brown figure in an exotic-fantasy landscape.

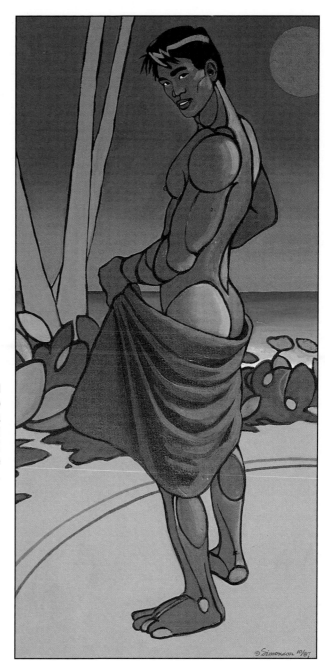

41

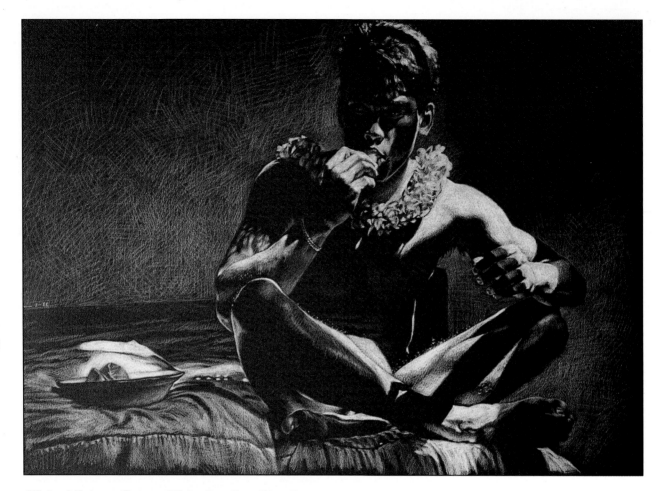

42

Michael Eats an Orange: White Pencil on Blue Paper,
August 1988. I take special delight in capturing the
absorption of a young man enjoying a sweet tropical
fruit. I had a special challenge here, since most of
Michael's face and body is in deep shadow. I used white
pencil to delineate the few bright spots of sunlight, and
merely suggested the rest.

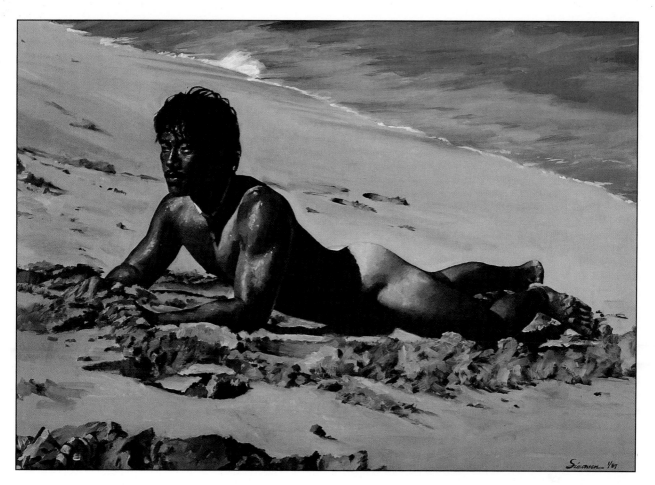

Sand: Acrylic, January 1987. One afternoon I took a Korean friend with a great, muscular body to Malaekahana Beach on Oahu. After playing in the surf, he came out of the water and played in the sand. The intensity of the late-afternoon Hawaiian sun creates strong contrasts here: the shadows are deep, and the model's still-wet skin throws back blinding highlights.

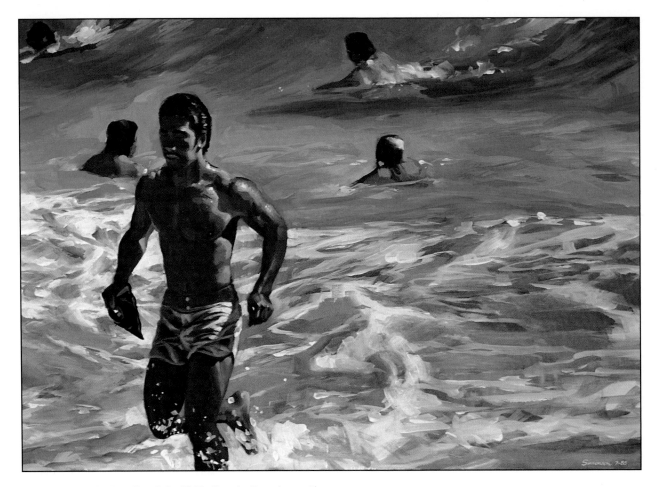

Sandy's No. 2: Acrylic, July 1988. Sandy Beach, on the island of Oahu, is bodysurfers' heaven. The waves roll in like this all year round, and if you want to return to the beach, sometimes you have to grab your fin and run to escape being washed back in. I used acrylic paint, sometimes purposely spattered, to capture the powerful movements of the ocean and the bodysurfers responding to it.

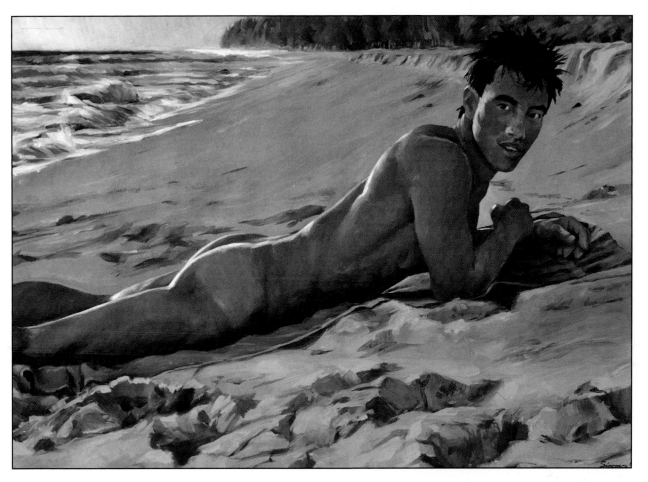

First Light: Acrylic, December 1987. It was still pitch black outside when I picked up a young friend who had finally agreed to model for me, and drove him to a secluded Oahu beach. We arrived just as the sky was beginning to lighten with the dawn. He took off his clothes, shivered, and bravely plunged into the cold surf. Moments later, he came running out of the water and threw himself down on the towel as the first rays of the rising sun broke over the horizon and gilded his body.

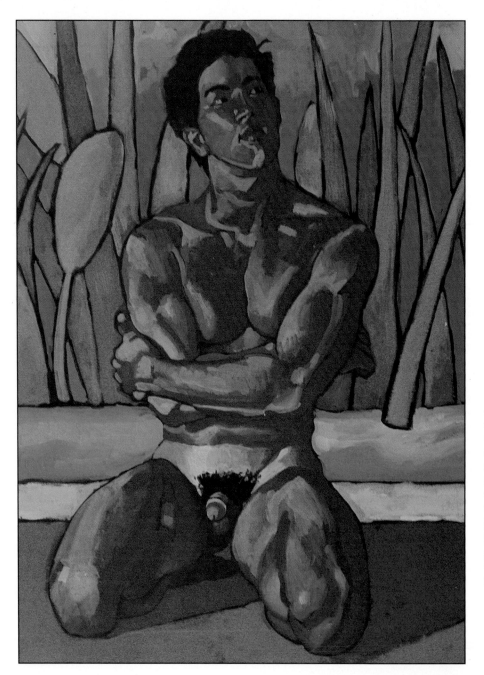

Bather by a River: Acrylic, July 1986. This painting of a young Chinese friend of mine was done with bold strokes and even bolder colors. Bruce posed in my living room, with a plain white wall behind him. When I began painting his body, I was inspired to invent a fantasy background. The title comes from a Matisse painting I've always loved.

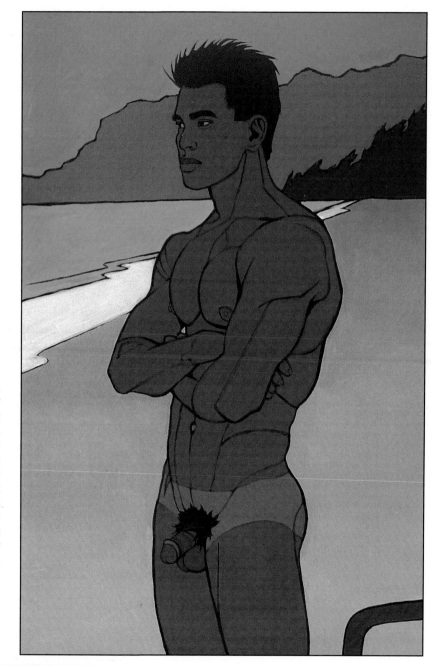

Red Chair: Acrylic, January 1988. Windward Oahu is one of my favorite spots for creating beach scenes. In this Eros Deco painting, I've used line rather than shadow and light to create the forms of the body. When the painting was nearly finished, I looked at it and it seemed somehow incomplete. In a flash of inspiration, I loaded my brush with red paint and added the arm of a beach chair in the lower right-hand corner.

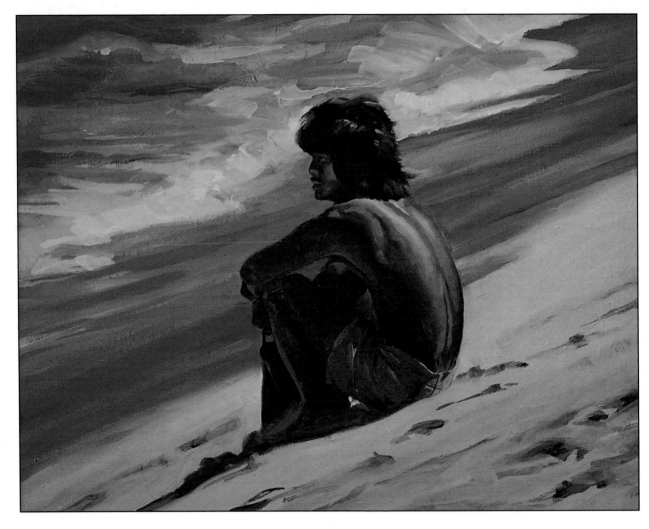

Psyching Up: Acrylic, January 1987. Though this is
a quiet, meditative pose, at any moment this young
bodysurfer will spring up and run into the surf. I used
quick, animated strokes to convey the power of the
ocean and the coiled energy of the figure.